KEEP
CALM
AND
SHUT THE F*CK UP

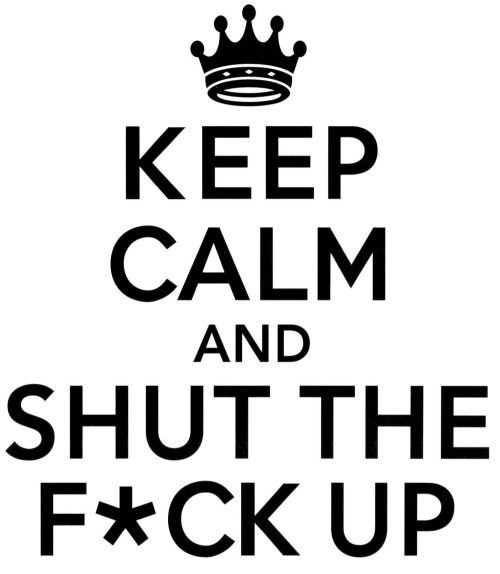

KEEP CALM

AND

SHUT THE F*CK UP

A Collection of 45+ Frameable
& Totally Relatable Art Prints

Avon, Massachusetts

Published by
Adams Media, a division of F+W Media, Inc.
57 Littlefield Street, Avon, MA 02322. U.S.A.
www.adamsmedia.com

ISBN 10: 1-4405-9476-7
ISBN 13: 978-1-4405-9476-2

Printed in Mexico.

10 9 8 7 6 5 4 3 2 1

Cover design by Elisabeth Lariviere.
Cover images © iStockphoto.com/nwinter.
Interior design by Elisabeth Lariviere and Frank Rivera.

This book is available at quantity discounts for bulk purchases.
For information, please call 1-800-289-0963.

WHAT

WOULD

DO?

I would

AGREE WITH YOU,

but then
we'd both

BE WRONG.

HANG

IN

THERE,

BITCH.

If you were
waiting
for a sign,

this is it.

I ♥ YOU MORE THAN

WELL AREN'T YOU JUST
A F*CKING RAY OF SUNSHINE.

GREAT MINDS

DRINK TOGETHER

P.S. Don't be like the rest of them, darling.

HOME

IS WHERE

THE PANTS

AREN'T.

People will stare;

make it worth their while.

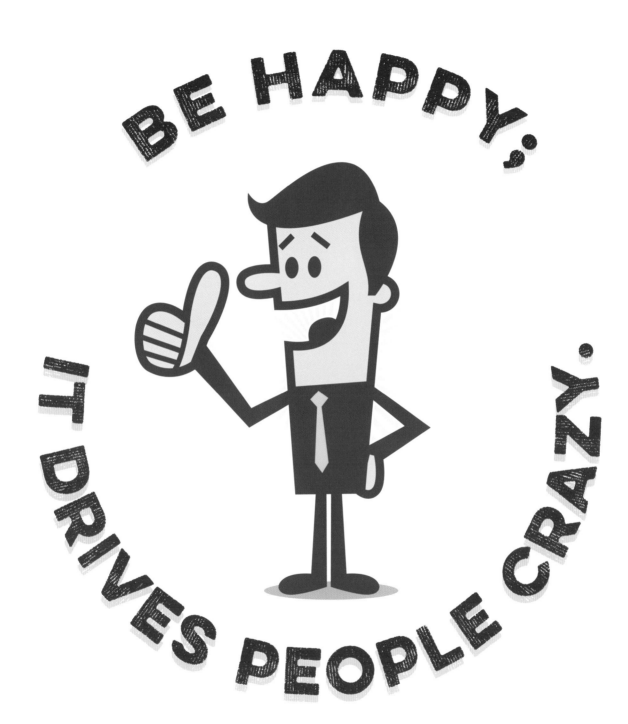

IF YOU CAN'T BE NICE,

THEN AT LEAST BE QUIET.

When life gives you lemons, add vodka.

Love you like a fat kid loves cake.

DON'T GROW UP. IT'S A TRAP.

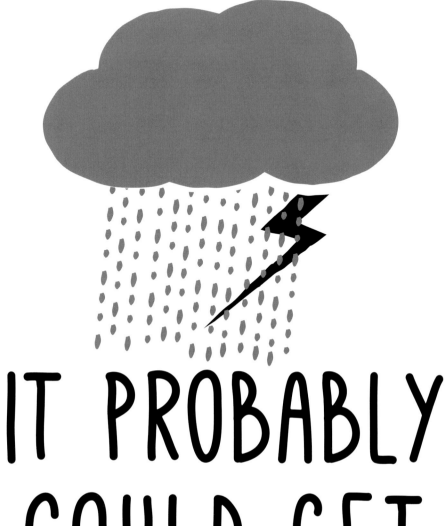

IT PROBABLY
COULD GET
WORST

FOXTROT.
UNIFORM.
CHARLIE.
KILO.

Some days, there just isn't enough wine in the world.

NEVER GIVE UP.

(UNLESS YOU REALLY SUCK.)

GO
AWAY

THERE ARE NO STUPID QUESTIONS, ONLY STUPID PEOPLE.

YOU CAN BE REPLACED

AND THOUGH

SHE BE LITTLE,

SHE BE

GODDAMN

FIERCE

WHY THE HELL NOT?

BLESS YOUR HEART.

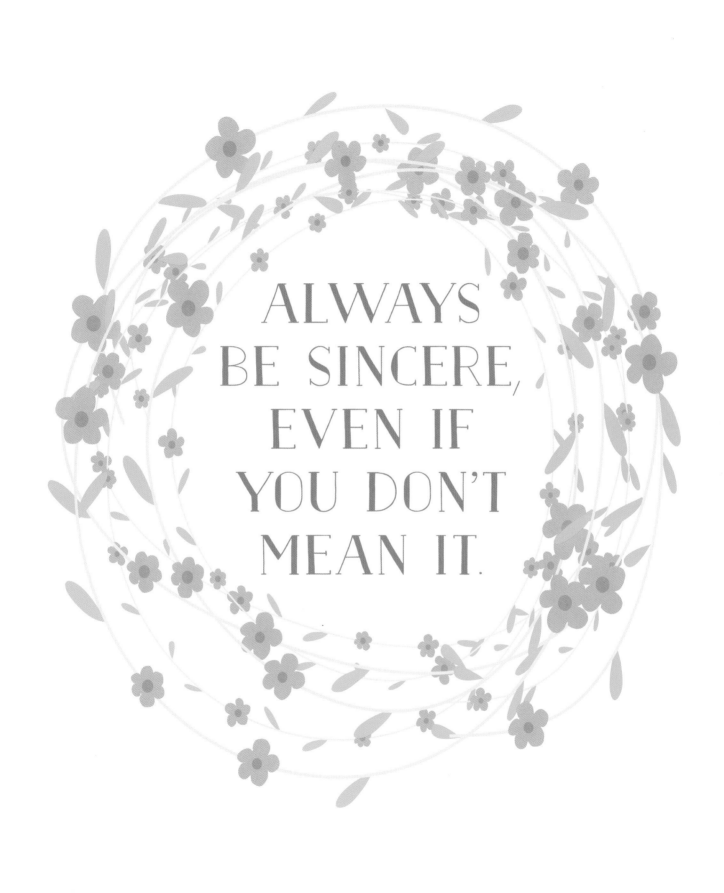

ALWAYS
BE SINCERE,
EVEN IF
YOU DON'T
MEAN IT.

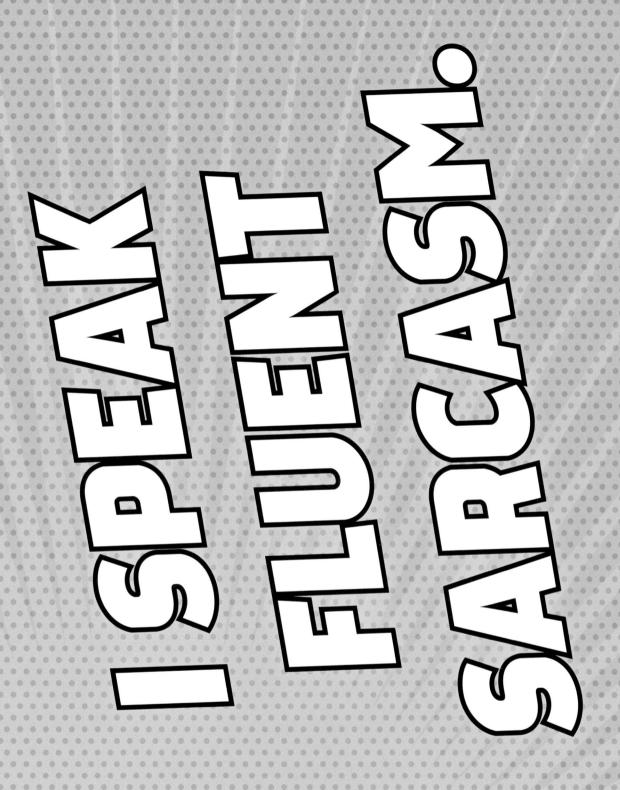

HOW ABOUT... NO?

. . . but first,
COFFEE

It is what it f*cking is.

Can you see the "*f*ck you*" in my smile?

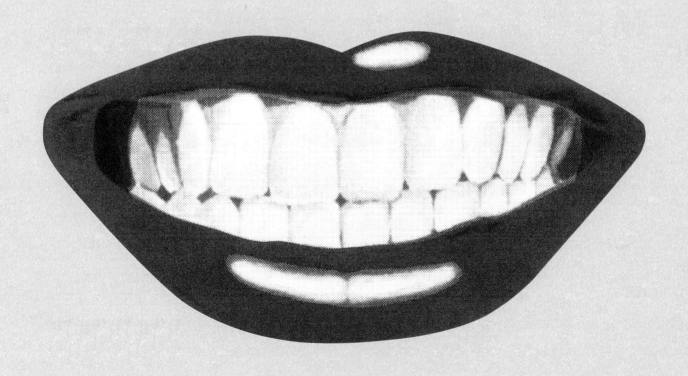

BADASS.

I HAVE **NOTHING** TO WEAR.

Get it, girl!

Vodka heals all wounds.

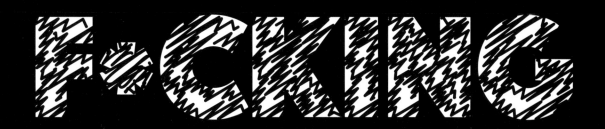
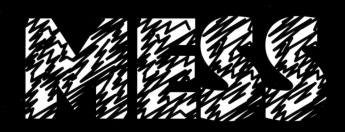
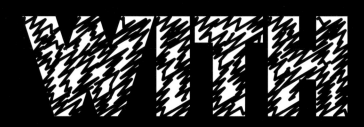
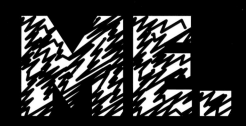

DON'T F*CKING MESS WITH ME.

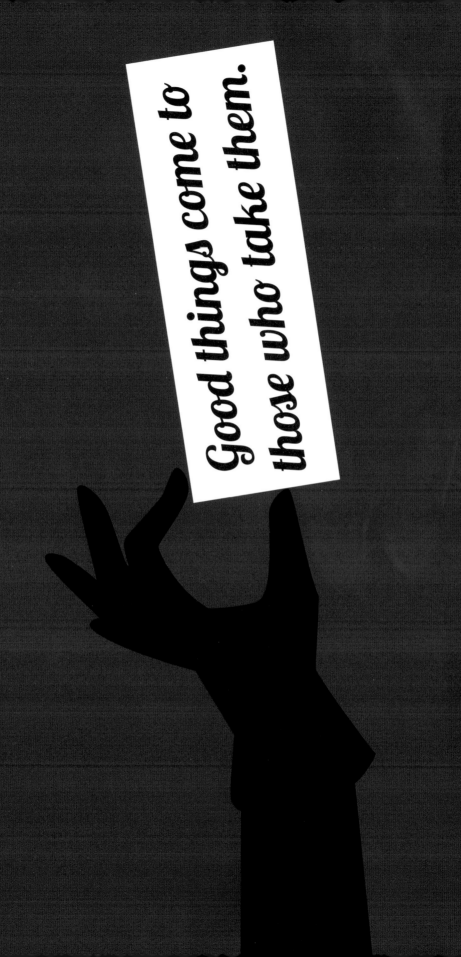

MAY YOU NEVER FEEL

OVERSCHEDULED

OR

UNDER-

CHARDONNAYED.

I'M ALLERGIC TO STUPIDITY. I BREAK OUT IN SARCASM.